PERSIANS

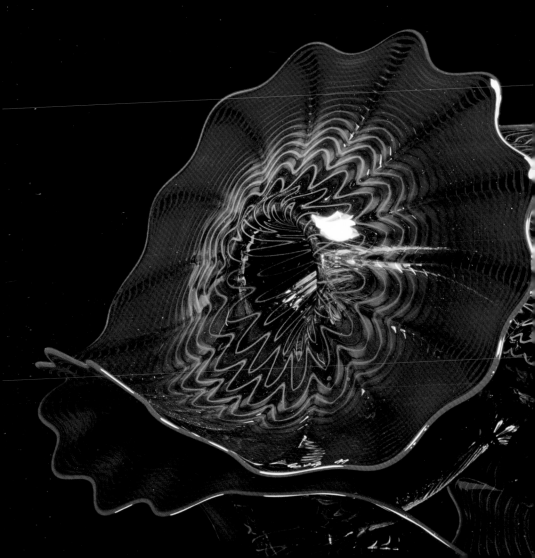

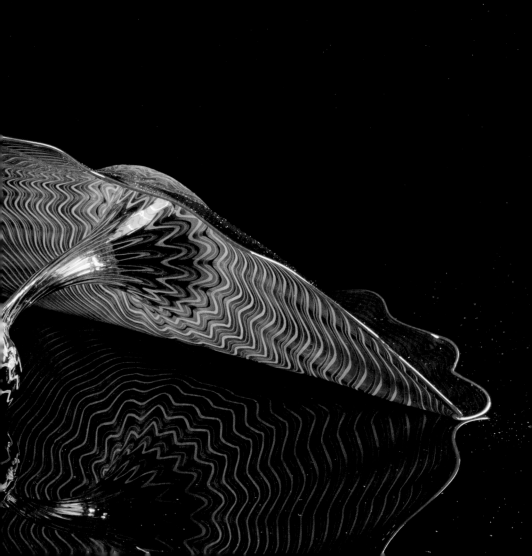

CHIHULY'S *PERSIANS*: REMEMBRANCES OF VENICE

DALE CHIHULY HAS FOUND THE *PERSIANS* TO BE HIS MOST EFFECTIVE vocabulary for installations. Stylized variations on glass spanning ancient to seventeenth-century models, the works in the series constitute the building blocks for diverse colorful sculptures that range from tabletop scale to monumental environmental forms that can be placed within, and interact with, bodies of water and other public areas. In that respect, the *Persians* established a precedent repeated in other Chihuly series such as the *Venetians*, *Chandeliers*, and *Putti*, in which he adapted earlier decorative art forms into a vehicle for contemporary sculptural expression.

Having gained considerable acclaim for his *Cylinder*, *Basket*, *Seaform*, and *Macchia* series, by the middle of the 1980s Chihuly was ready to create a new vocabulary. In anticipation of a landmark one-person show in Paris's Musée des Arts Décoratifs at the Palais du Louvre in December 1986, Chihuly asked Martin Blank to serve as lead gaffer and blow more than a thousand miniature experimental forms under Chihuly's guidance over a yearlong period. Some of the earliest *Persians* resemble the *Macchia* series: their solid-colored interiors are juxtaposed against contrasting mottled exteriors and topped with colorful lip wraps. By the late 1980s, the dramatic differences between interior and exterior had largely disappeared.

Preceding page:
Cobalt Persian Pair
with Red Lip Wraps

1997, 14 x 33 x 25"

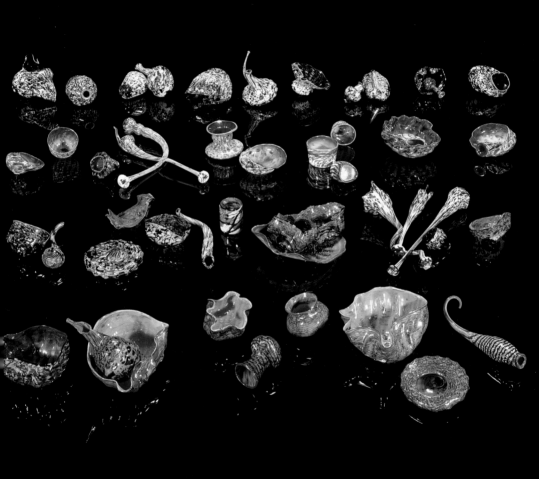

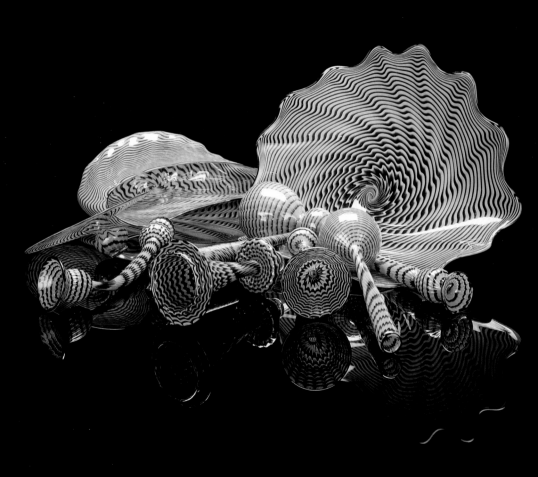

Various references and influences have been suggested by writers commenting on the origins of the *Persian* series. Chihuly himself claims that he never researched the Islamic arts; instead, he says he found inspiration for the series in a cycle of seven paintings by Vittore Carpaccio (Italian, c. 1460–c. 1526) that he saw at the Scuola di San Giorgio degli Schiavoni in Venice in 1968. In an unfinished statement entitled "The *Persians*, or Carpaccio *Persians*," Chihuly wrote in 1988 that he discovered the *scuola* while wandering the city streets. He added, "For me these seven paintings were as unique as Venice itself."

Previously, art historians have cited the painting *Saint George and the Dragon* as the most influential one in Carpaccio's cycle, drawing comparisons between Chihuly's grouping of forms and the scattered fragments of the dragon's victims in the foreground, and finding parallels between the patterning of the dragon's wings and the *Persian* rondel forms. However, *The Vision of Saint Augustine*, considered the masterpiece of this cycle, could have been equally critical. Illustrating Venice's fascination with Byzantium even during the Renaissance, it shows the saint in his studio surrounded by numerous Islamic objects.

These include a wide array of metalwork, two long-necked glass flasks, and a wide-mouthed, round ceramic pot with a large, flaring, truncated neck that references Mamluk and Ottoman mosque lamps. Interestingly, in all his discussions of the origins of the Persians, Chihuly has never mentioned these particular objects, only his general fascination with Venice and its Near and Far Eastern underpinnings.

Ribbed optic molds, which had proved so successful in creating the *Seaforms*, became essential to the *Persians'* aesthetic. While the linear wraps used to surround the *Seaforms'* hot glass bubbles were very thin, thick wraps were used for the *Persians*. Chihuly learned about wraps in Venice at the Venini workshop in 1968, which was critical not only for his own development but for American artists in general. When plunged into these molds, the hot glass bubbles, with their thick circular wraps of two or more opaque and contrasting colors, develop strong, repetitive, herringbone patterns; twisting the bubble produces swirling configurations. Once removed from the molds and blown out, the hot glass is transferred to the pontil rod and rotated, creating irregularly shaped rondels. These are the most spectacular of the *Persian* forms, because of their scale and undulating walls and lips.

Persian in process

The Boathouse hotshop
Seattle, Washington, 2006

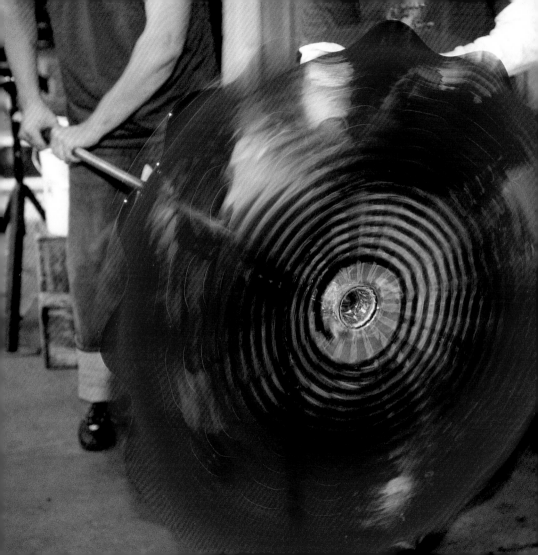

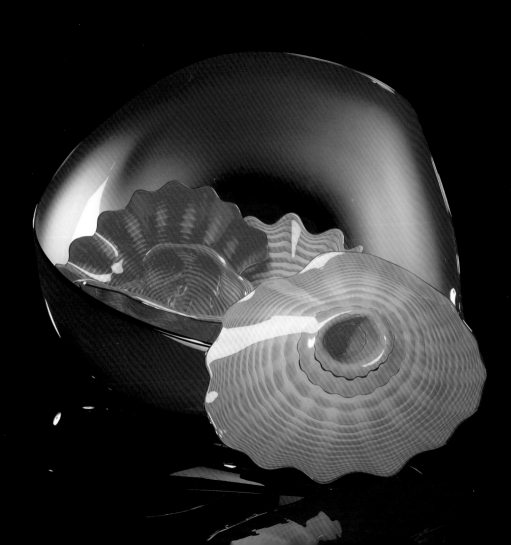

Whatever its origins and fabrication, the *Persian* series visually evokes historical decorative arts. The first *Persians* ranged from vessels suggesting ancient eastern Mediterranean core-formed glass to others reminiscent of small *Seaforms*, *Baskets*, and early *Macchia*. They also included pulled, linear, hollow forms that resemble the tall, narrow necks of medieval Islamic bottles with globular bodies. Cone forms, often with tiny blown elements at one end, resemble stylized adaptations of mosque lamps. Long, narrow, slightly curved hollow forms with upside-down, teardrop-shaped openings became hallmarks of the series and were abundant by 1987–88. These *Persians* suggest earlier wares developed during the seventeenth century indigenously in what is now Iran or by Persian craftsmen knowledgeable in Venetian styles. As Chihuly's *Persian* series matured into the 1990s, the elements resembling ancient core-formed glass, as well as vocabulary from his earlier series, were replaced by more exotic versions of Islamic glass; sometimes his asymmetrical rondels were even substituted for the Islamic-influenced elements.

Over the years, the *Persians* have appeared in increasingly dramatic installations. Initially, the small

Permanent Blue and Orange Stemmed Persian Set with Dark Blue Lip Wraps

1988, 22 x 30 x 17"

experimental forms, which Chihuly described as "geometric," were arranged by color in rows on a tabletop. By 1988, individual elements were placed on shelves and/or juxtaposed within larger, more organic tazza forms, which were soon replaced by the rondels. Over the years, these assemblages of glass elements have become more and more complex: smaller forms sometimes spill out of larger rondels to create compositions that range up to almost six feet in width. At other times, single rondels are either placed side by side or intertwined, all resulting in commanding microenvironments.

As the rondels were perfected, they were wall-mounted in site-specific installations, initially juxtaposed with loosely arranged smaller forms on shelves or densely packed into large wall cases. By 1991–92, the rondels had become the primary elements of monumental environments. Wall- and window-mounted armatures were created so they could be installed sparingly or in groups to fill large expanses. The rondels in window settings readily recall those created by Chihuly and James Carpenter in their collaborative doors and windows of the 1970s. More recently, these elements have been used in some *Chandeliers*, most successfully in the asymmetrical,

Puget Sound Persian
Installation

The Pilchuck Glass Collection at
City Centre, Seattle, Washington
1989, 10 x 12 x 7½'

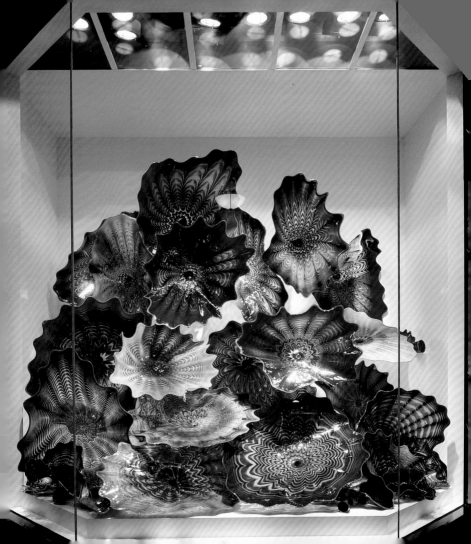

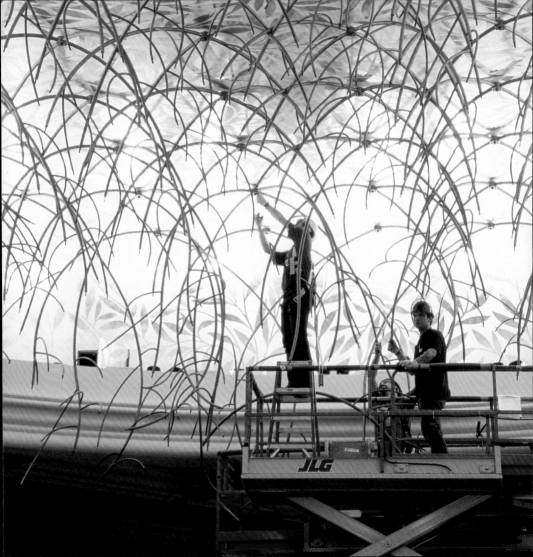

peony-like examples such as the one at the Flint Institute of Arts in Michigan (2009).

A major project to create a work for the lobby of the Bellagio Resort in Las Vegas, Nevada, during 1997–98 led to a series of exquisite ceilings and pergolas, as well as to several arbor-like structures situated within botanical-garden glasshouses. While the Bellagio ceiling used an elaborate metal framework to suspend approximately two thousand rondels, other approaches include large transparent *Persians*, at times resting upon tiny Islamic-influenced elements, piled directly upon plate glass or individually affixed to weathered timbers.

Chihuly has also used the *Persian* rondels in water environments. One of the most innovative is the lap pool of his own space in Seattle, Washington, The Boathouse (1994, redesigned 2000), which he initially envisioned as the site of a performance. Placed untethered in the pool, the *Persians*, along with *Seaforms*, *Putti*, and small *Floats*, were intended to move in the ripples caused by swimmers. Unfortunately, the dangers inherent in unfettered moving glass led to a redesign, with all the sculptures layered under plate glass at the bottom of the pool. Since the millennium, Chihuly has explored the water theme

Fiori di Como, installation

Bellagio Resort, Las Vegas, Nevada
1998, 70 x 30 x 12'

further in conservatories: rondels float like Monet's water lilies in indoor ponds or hover like butterflies in vegetation above pools.

Davira S. Taragin
Former Director of Exhibitions and Programs,
Racine Art Museum;
former Curator, The Detroit Institute of Arts,
Toledo Museum of Art

Lap Pool

The Boathouse, Seattle, Washington
1994, 12 x 54 x 4'

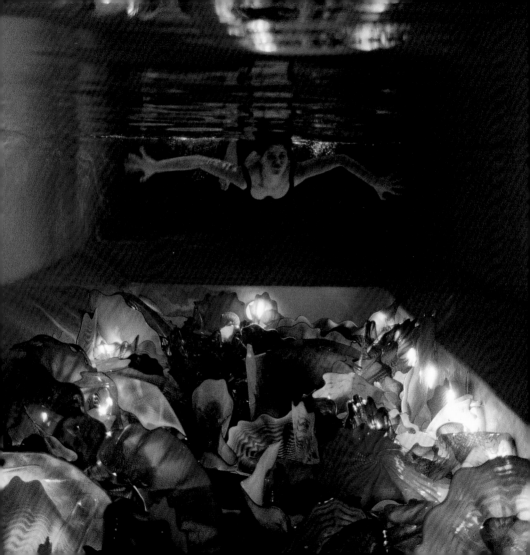

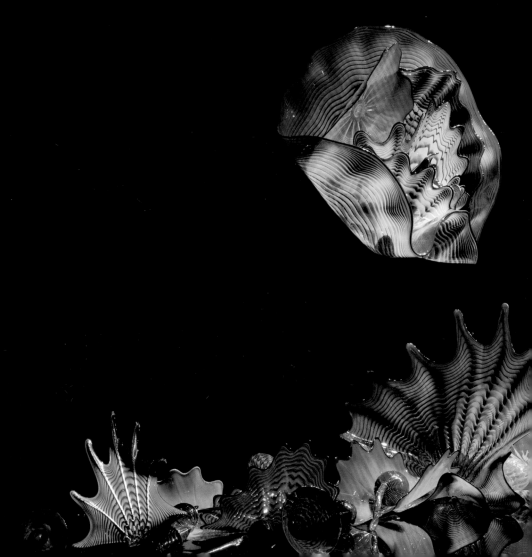

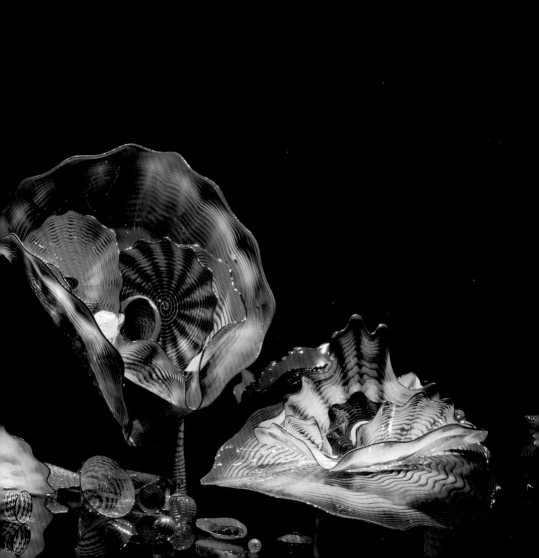

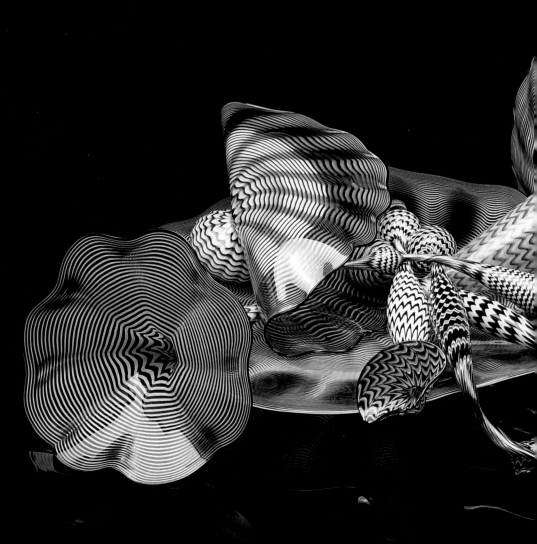

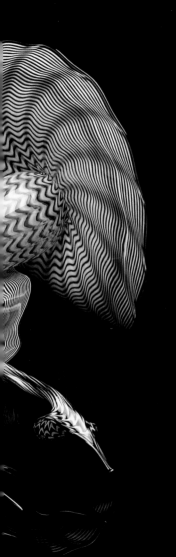

White and Russet Persian Set

1989, 14 x 31 x 28"

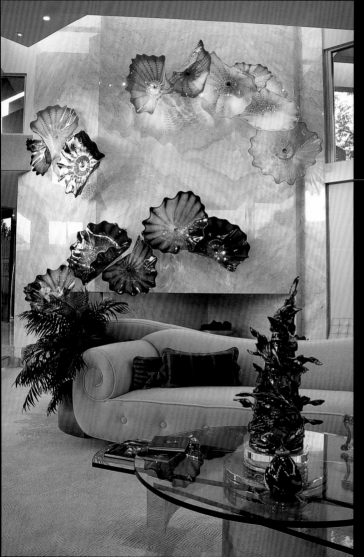

Indian Wells Persian Wall

Private residence
Indian Wells, California
1994

Chrome Green and Orange Persian Set

1988, 16 x 22 x 27"

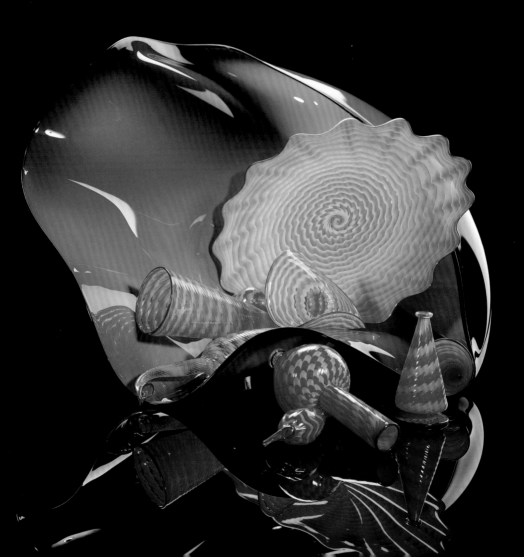

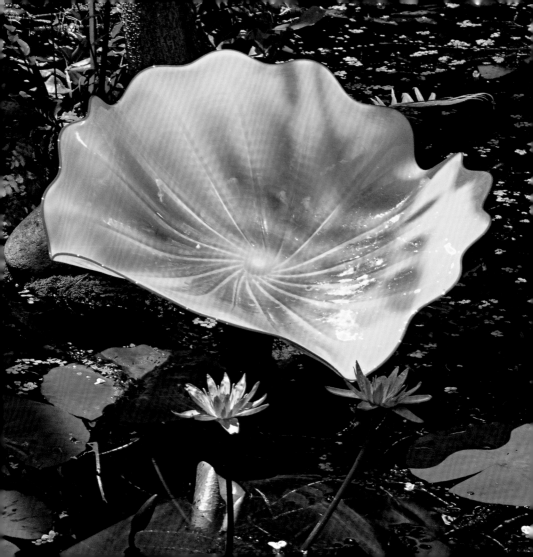

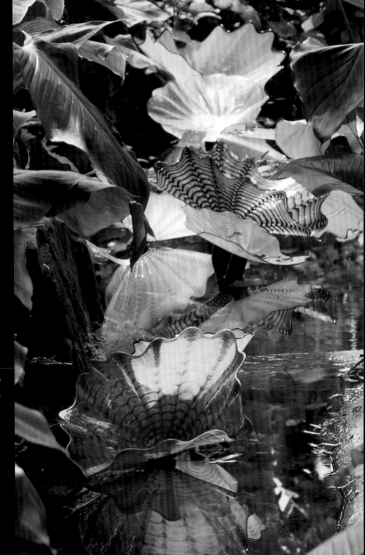

Persian Pond

Atlanta Botanical Garden
Atlanta, Georgia, 2004

Temperate House Persian Pond

Royal Botanic Gardens, Kew
Richmond, England, 2005

**James Mongrain,
Eric Pauli, and Chihuly**

The Boathouse hotshop
Seattle, Washington, 2000

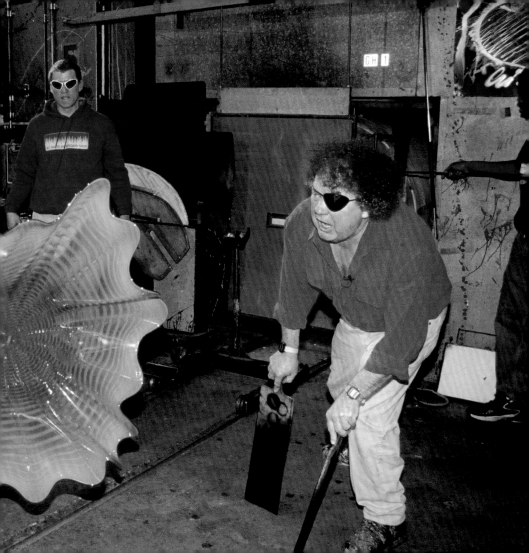

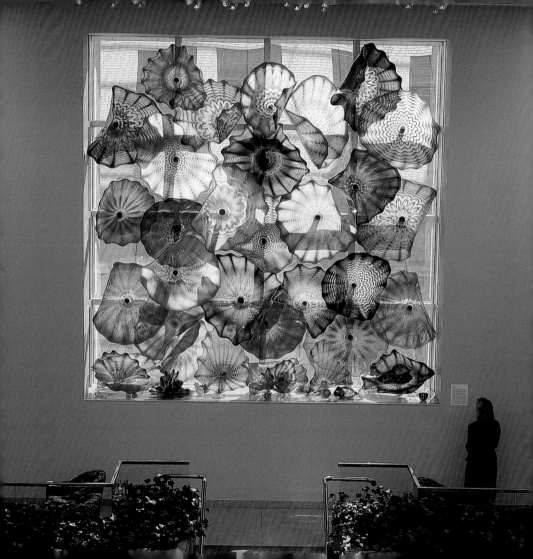

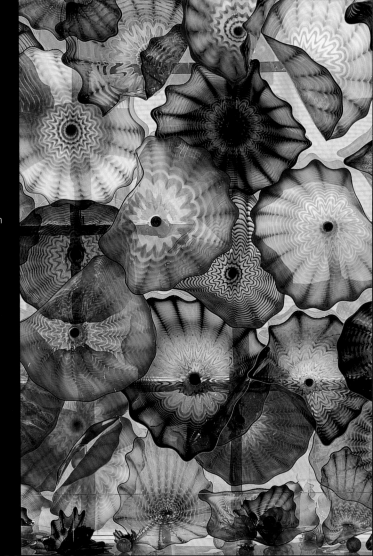

Malina Window

Little Caesar Enterprises Inc.
Corporate Headquarters
Fox Office Centre, Detroit, Michigan
1993, 16 x 16'

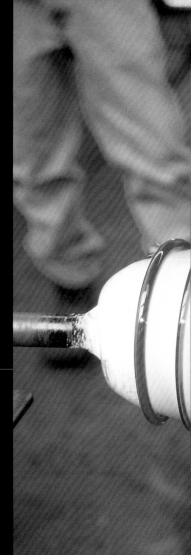

Applying a body wrap

The Boathouse hotshop
Seattle, Washington, 2006

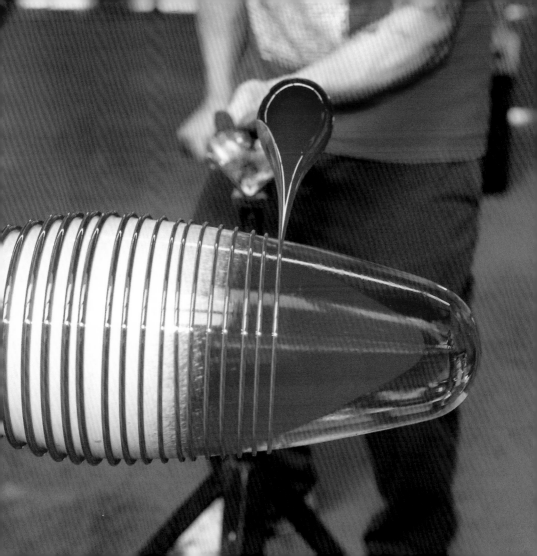

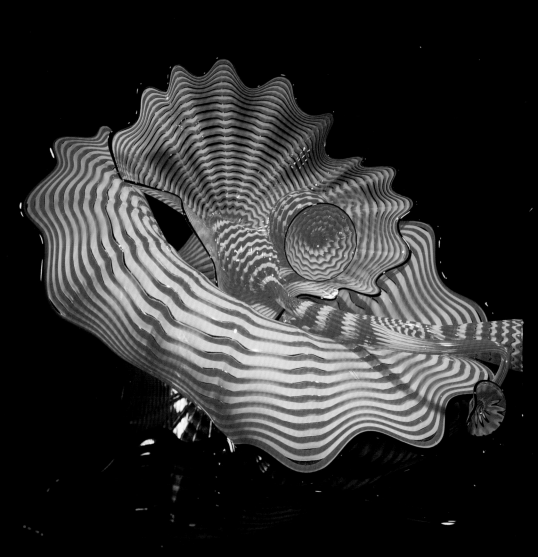

Cinnabar and Coral Persian Set
with Black Lip Wraps

1998, 10 x 20 x 17"

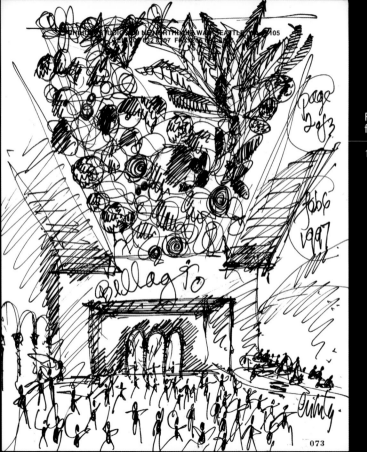

Fax sketch of Persians
for Bellagio Resort

1997

Dale Chihuly

The Boathouse
Seattle, Washington
1998

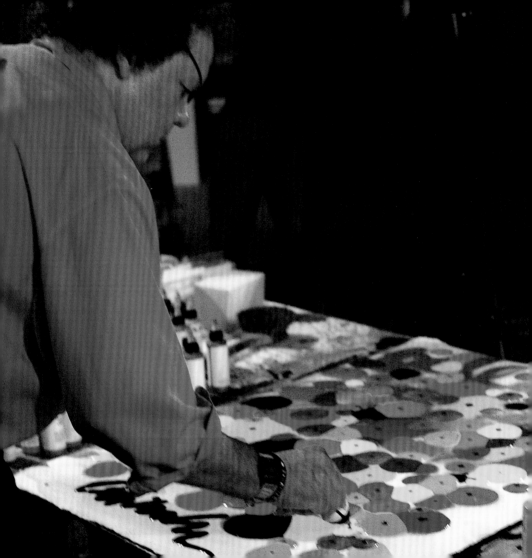

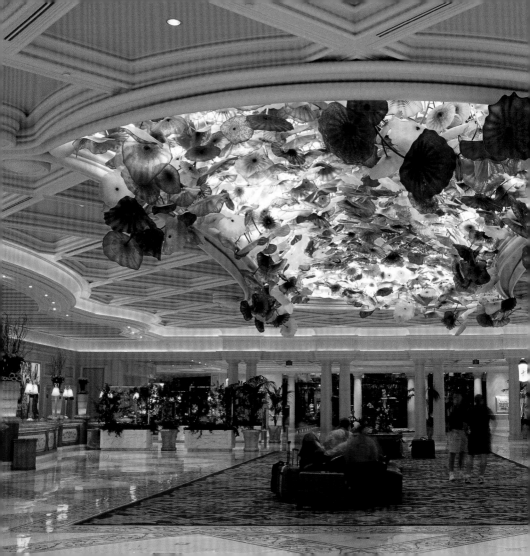

Fiori di Como

Bellagio Resort, Las Vegas, Nevada
1998, 70 x 30 x 12'

Dusky Violet Persian

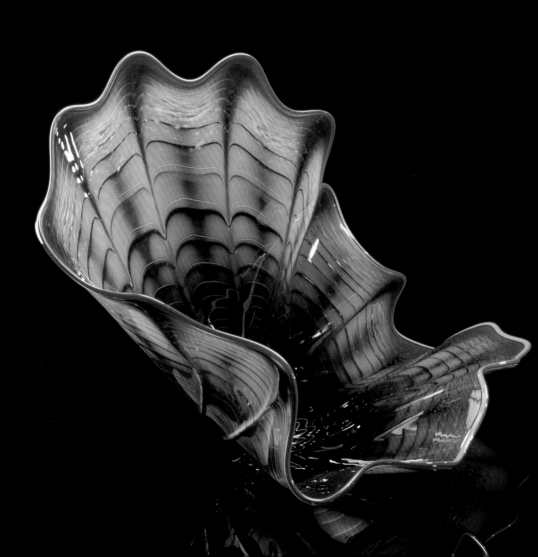

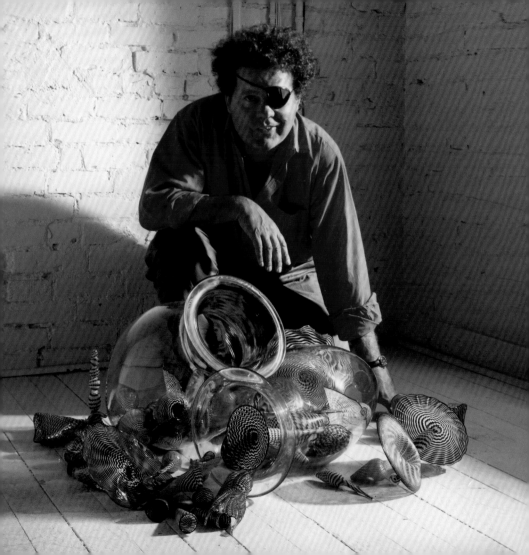

Preceding page:
Dale Chihuly with Persians

Chihuly Studio, Tacoma, Washington, 1987

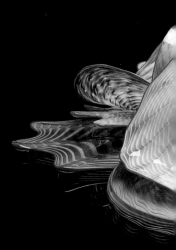

Lavender and Blue Wrapped
Persian Set with Red Lip Wraps

1988, 13 x 42 x 32"

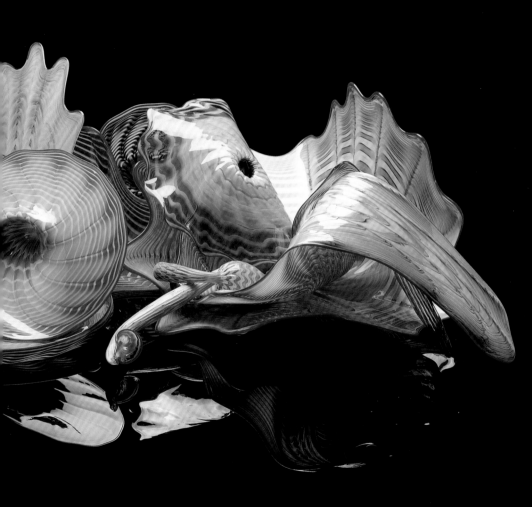

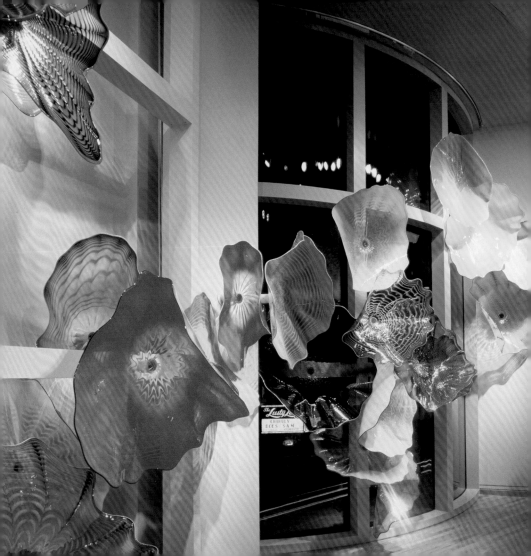

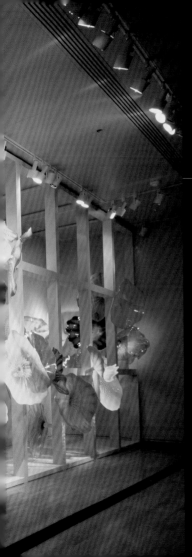

Venturi Window

Seattle Art Museum, Seattle, Washington
1992, 48 x 16 x 7'

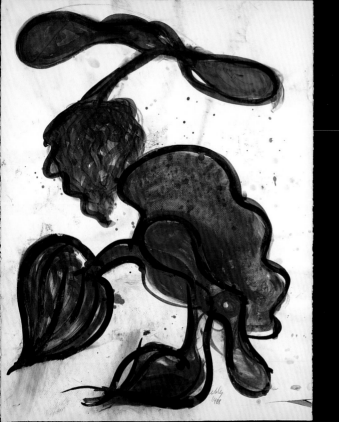

Persian Drawing

1988, 30 x 22"

Brilliant Blue and
Cavalry Orange Persian Set

1989, 14 x 27 x 17"

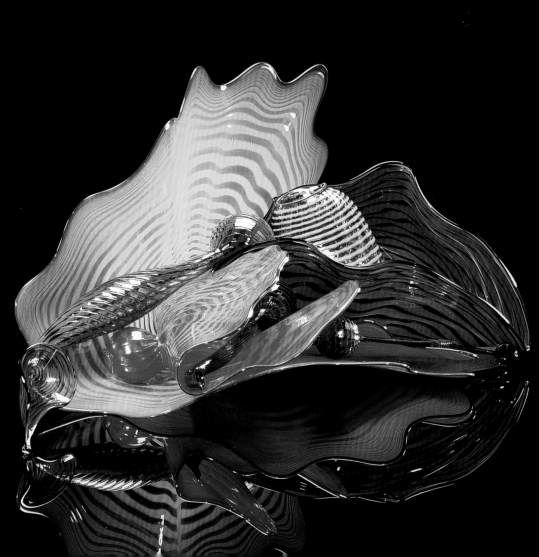

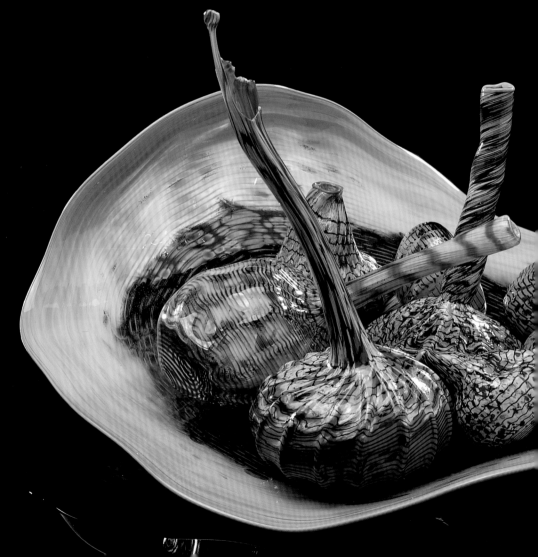

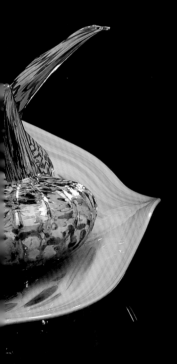

Lime Persian Set with Rhodonite Lip Wraps

1988, 6 x 14 x 12"

Union Station Drawing

1993, 22 x 30"

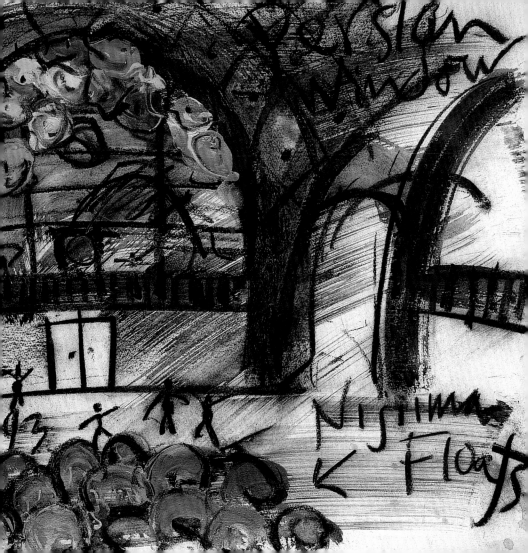

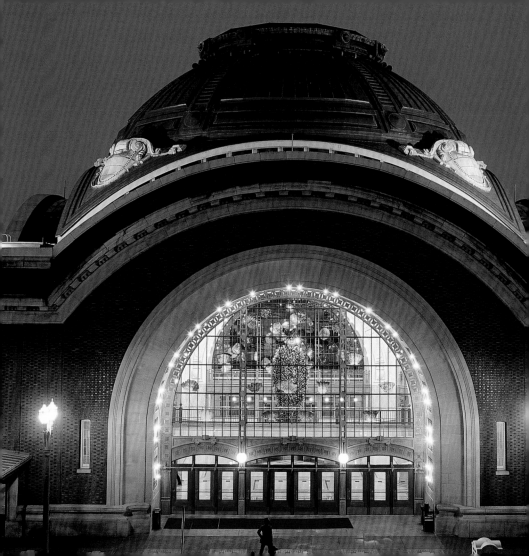

Monarch Window

Union Station, Tacoma, Washington, 1994

Monarch Window

Union Station, Tacoma, Washington, 1994

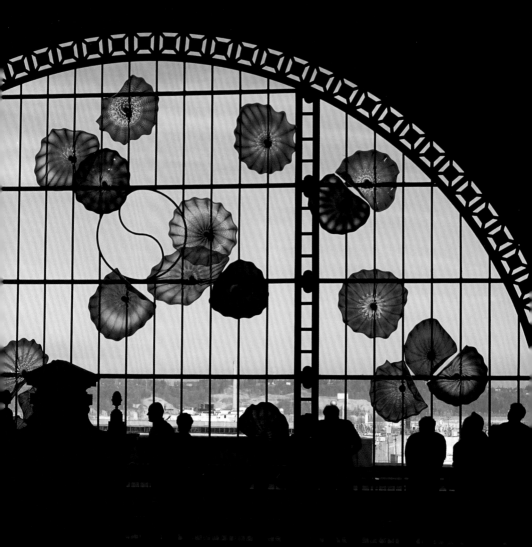

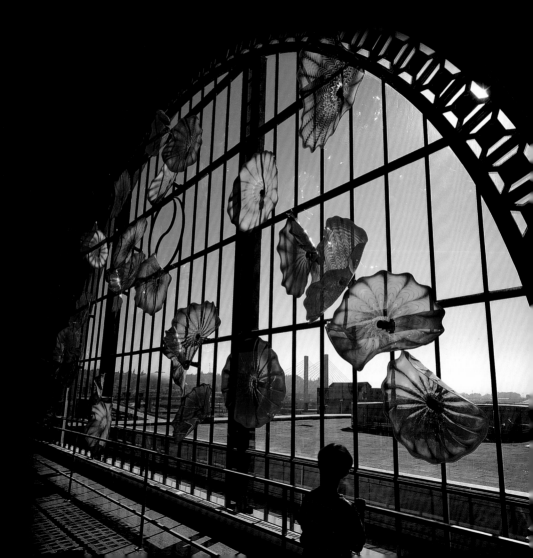

Monarch Window

Union Station,
Tacoma, Washington, 1994

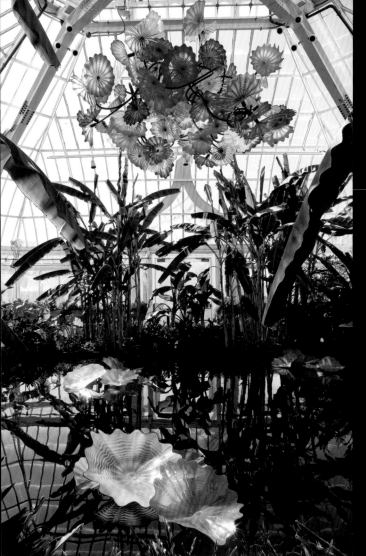

**Persian Chandelier
and Persian Pond**

Phipps Conservatory
and Botanical Gardens
Pittsburgh, Pennsylvania, 2007

Persian Chandelier

Royal Botanic Gardens,
Kew, Richmond, England
2005, 8 x 10 x 9'

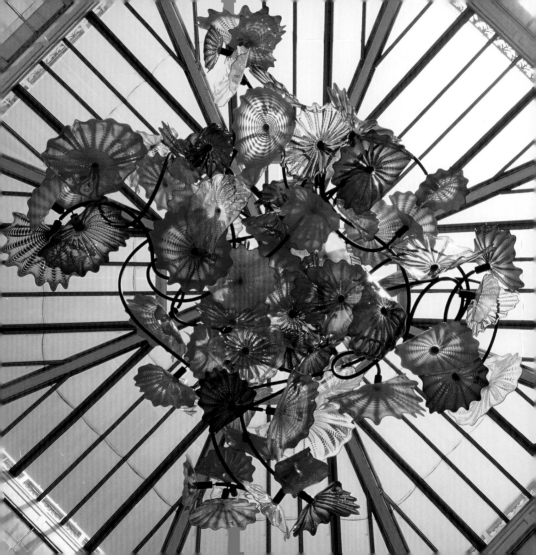

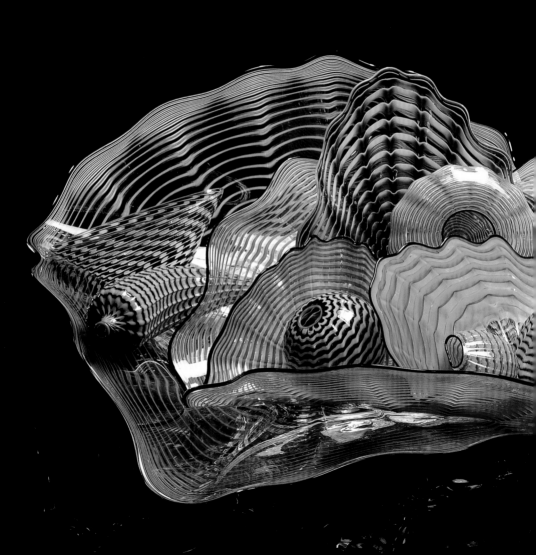

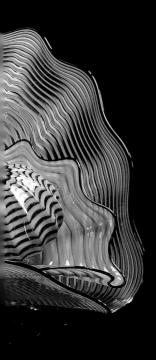

Sun Rose and
Olive Brown Persian Set

1998, 11 x 30 x 25"

Autumn Gold Persian Wall Installation

Oklahoma City Museum of Art
Oklahoma City, Oklahoma
2002, 9½ x 32'

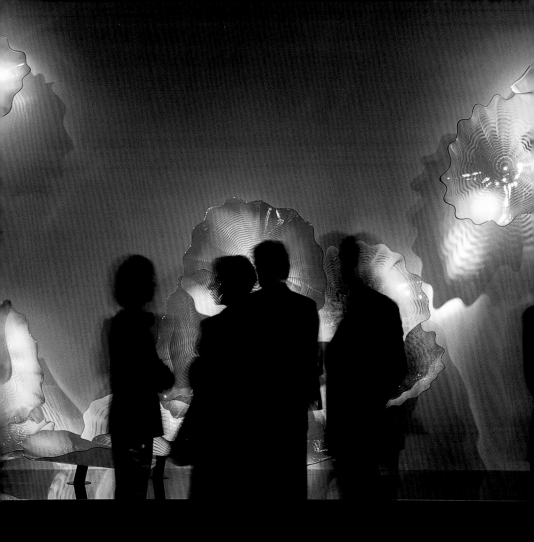

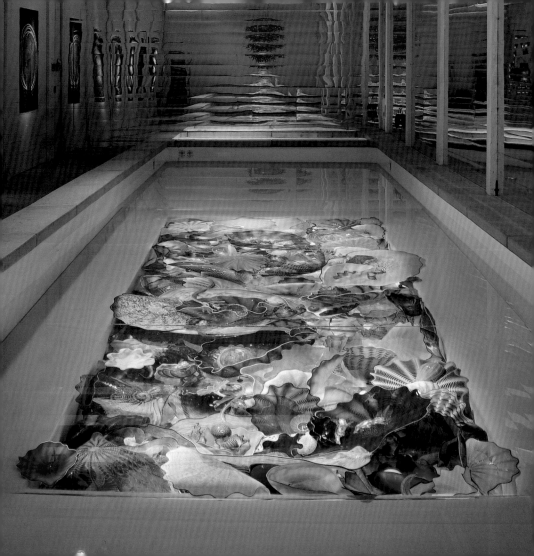

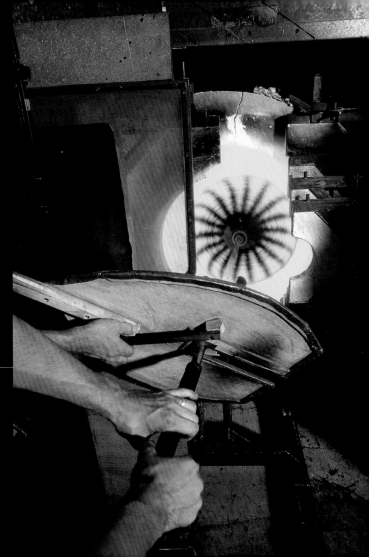

Lap Pool

The Boathouse
Seattle, Washington
1994, 12 x 54 x 4'

Persian in process

The Boathouse hotshop
Seattle, Washington, 1999

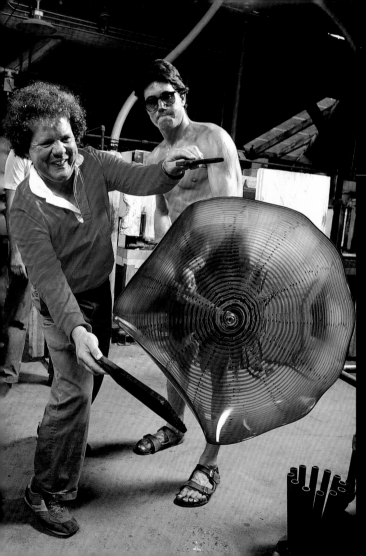

Chihuly and William Morris

Pilchuck Glass School
Stanwood, Washington, 1983

Oxblood and Cream
Persian Set

1987, 10 x 21 x 21"

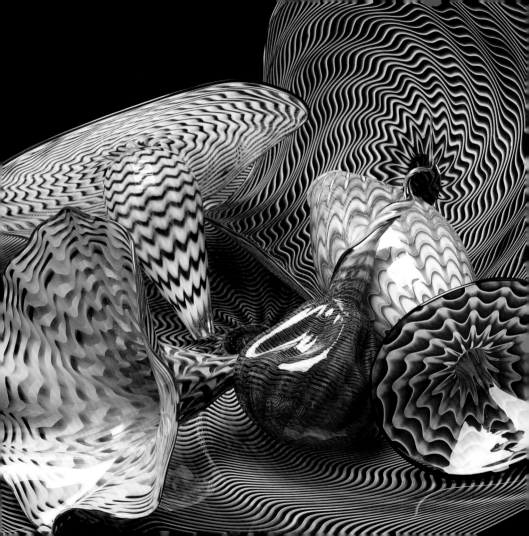

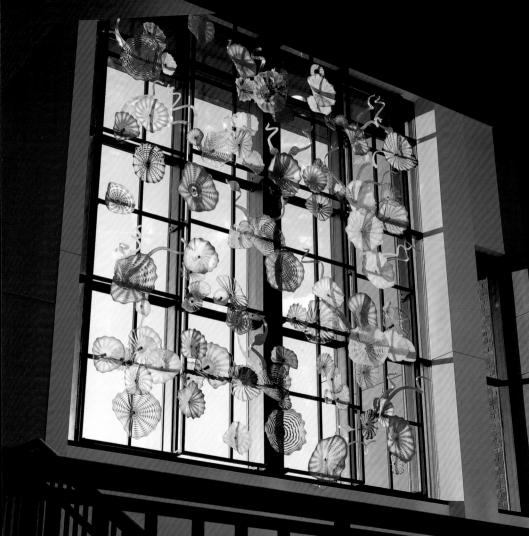

The Chihuly Window

University of Puget Sound
Tacoma, Washington
2000, 19½ x 17'

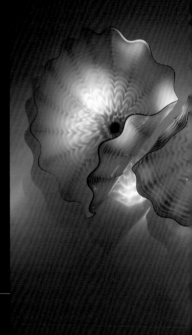

Golden Celadon Persian Installation

1994, 10½ x 17'

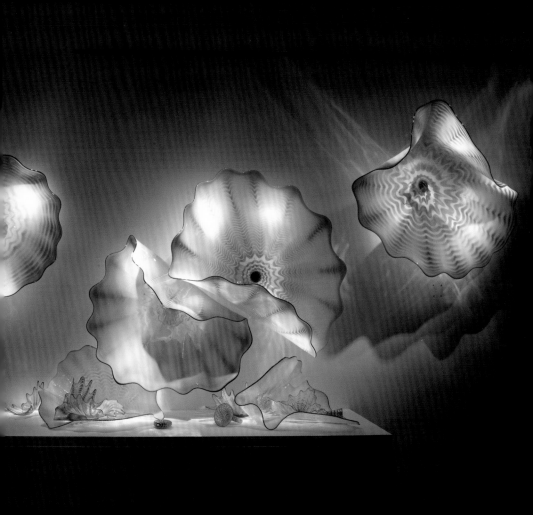

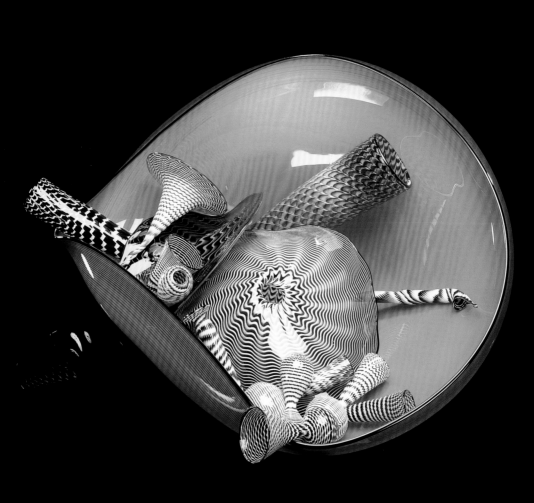

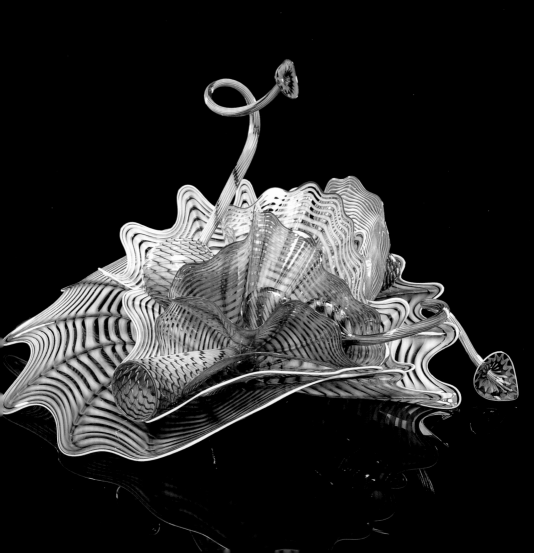

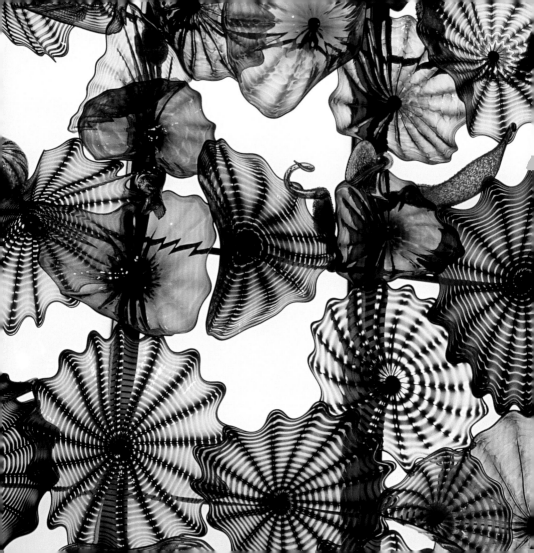

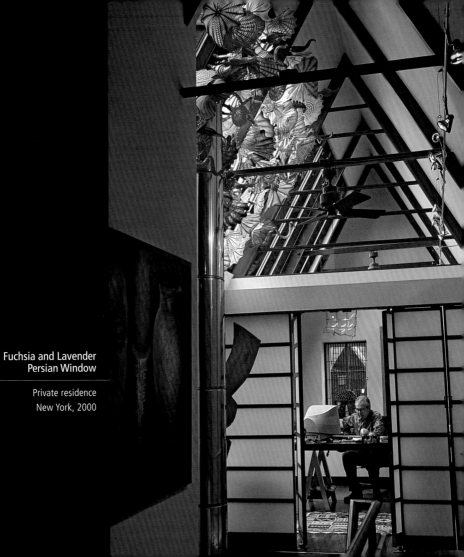

**Fuchsia and Lavender
Persian Window**

Private residence
New York, 2000

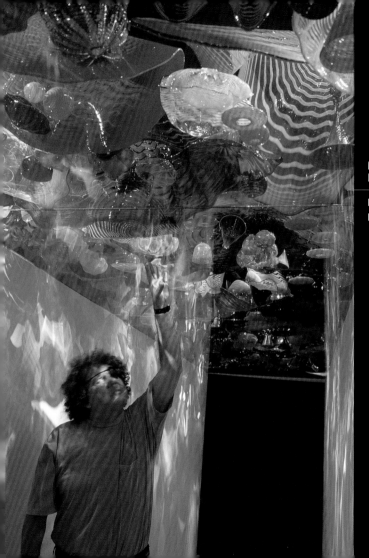

Dale Chihuly beneath
Persian Ceiling

Detroit Institute of Arts
Detroit, Michigan, 1993

Electric Orange Persian Set
with Cobalt Lip Wraps

2000, 10 x 15 x 17"

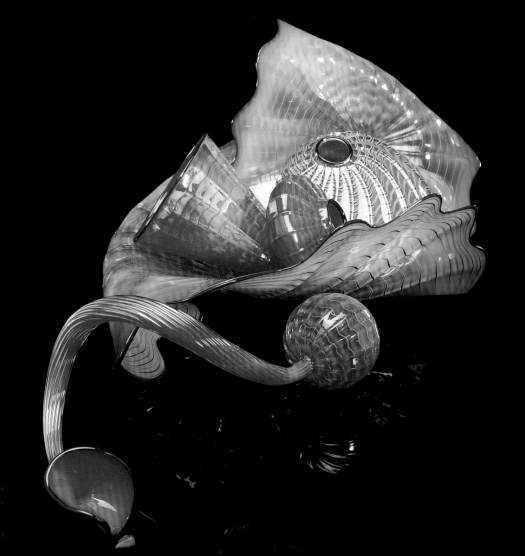

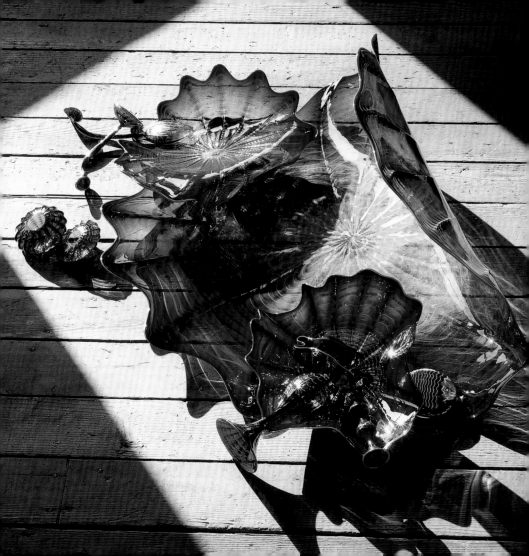

Cobalt Blue Persian Set
with Garnet Lip Wraps

1994, 16 x 45 x 32"

Persian Drawing

1988, 30 x 22"

Cadmium Yellow Persian
with Red Lip Wraps

1990, 13 x 41 x 41"

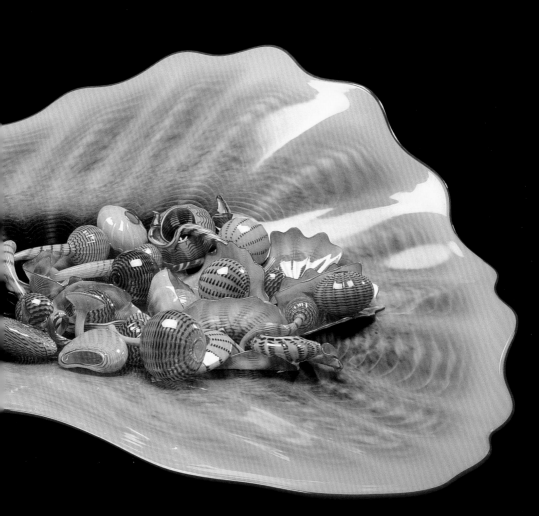

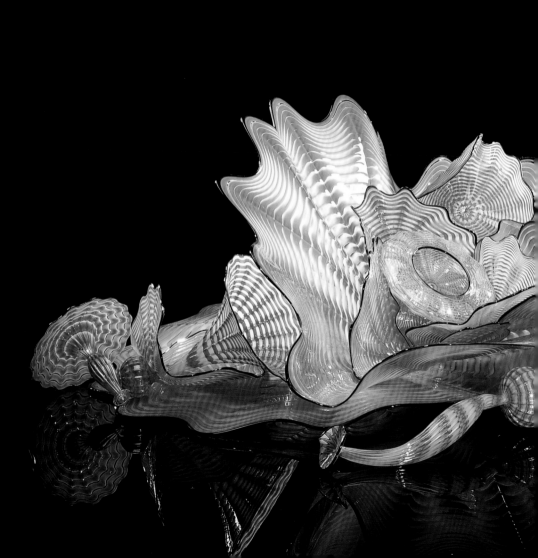

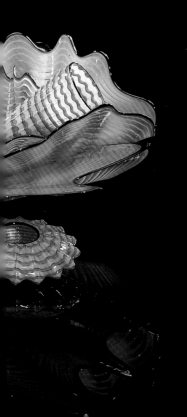

**Pink and Orange Persian Set
with Onyx Lip Wraps**

1999, 14 x 33 x 24"

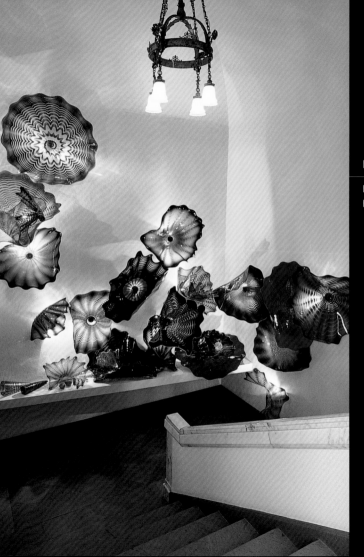

Persian Wall

Private residence
Radnor, Pennsylvania, 1989

Blue Persian Set with
Warm Red Lip Wraps

1994, 12 x 18 x 10"

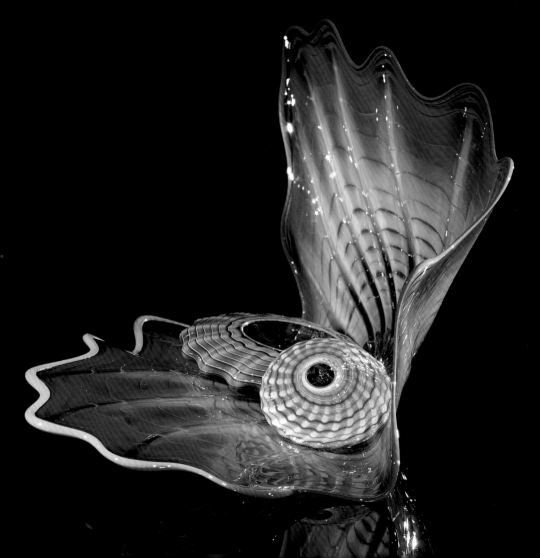

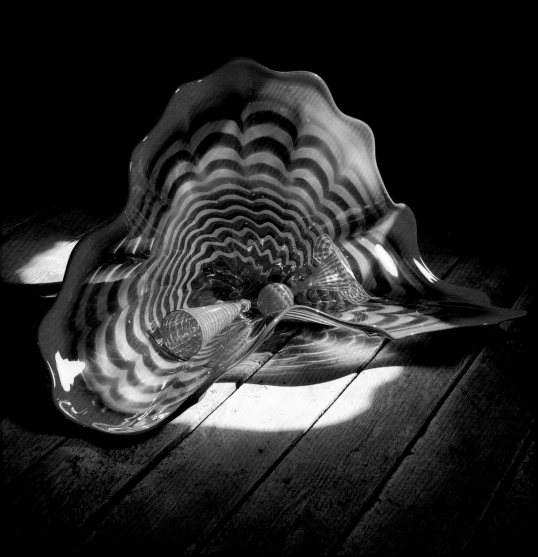

Ruby Persian Set
with Cobalt Lip Wraps

1992, 18 x 23 x 15"

Fax sketch of a Seaform / Persian
Ceiling for Lagerquist Concert Hall
Pacific Lutheran University
Tacoma, Washington

1994

2.14.94 Happy Valentines Day

" Seaform Persian Ceiling
Relates to Seaforms in
Concert Hall.)

wow!

LAGERQUIST

Ceiling should probably
take up about ½ of the
lobby area — several hundred
pieces in the ceiling perhaps.
Talk soon
Chihuly

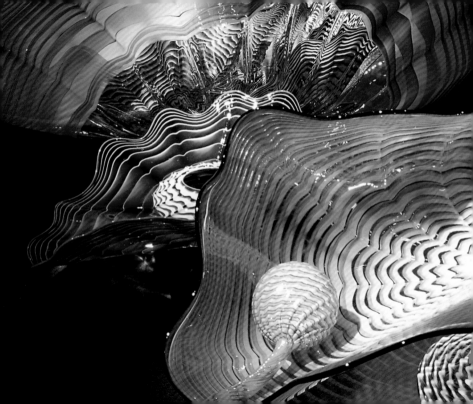

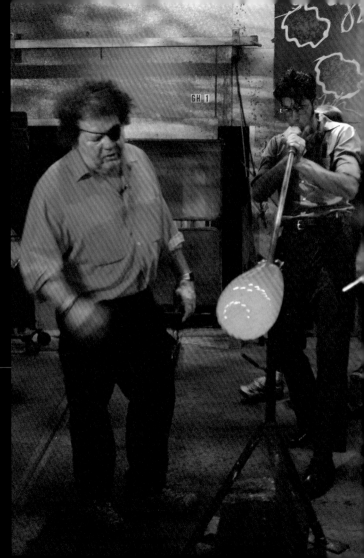

Coral Blush and Olive Persian Set

2002, 20 x 44 x 44"

Chihuly and James Mongrain

The Boathouse hotshop
Seattle, Washington, 1998

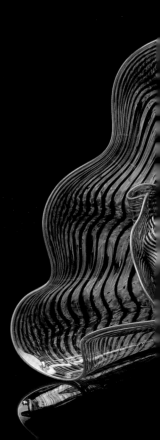

**Amber Brown Persian Set
with Red Jasper Lip Wraps**

2003, 18 x 27 x 23"

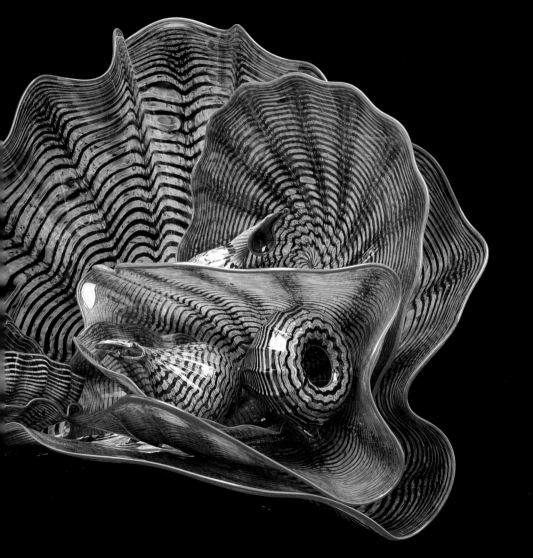

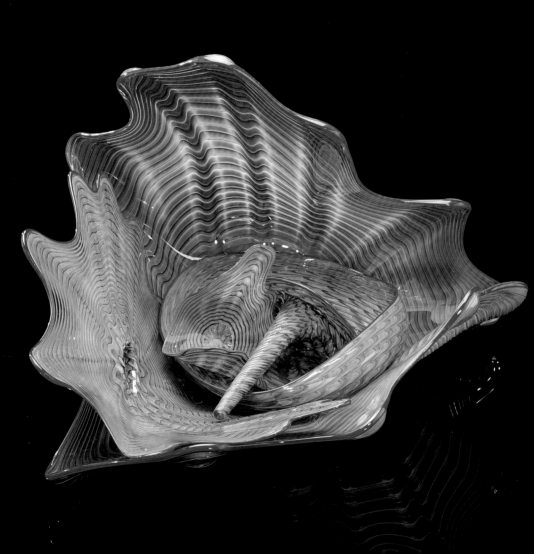

Olive and Poppy Persian Set
with Crimson Lip Wraps

1989, 17 x 30 x 23"

Seattle Art Museum
Persian Ceiling Drawing

1992, 30 x 22"

James Mongrain and Daryl Smith

The Boathouse hotshop
Seattle, Washington, 2006

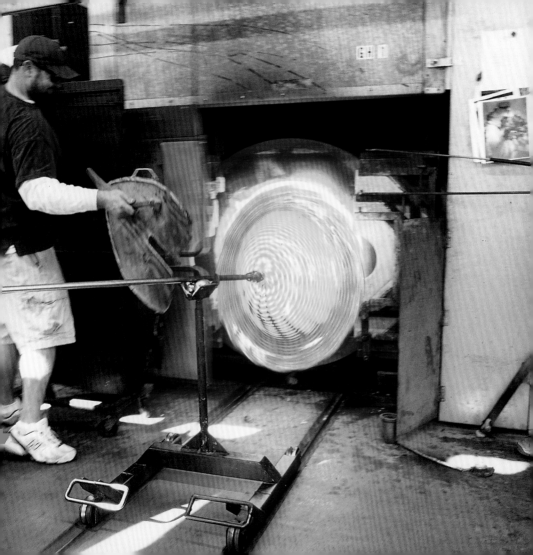

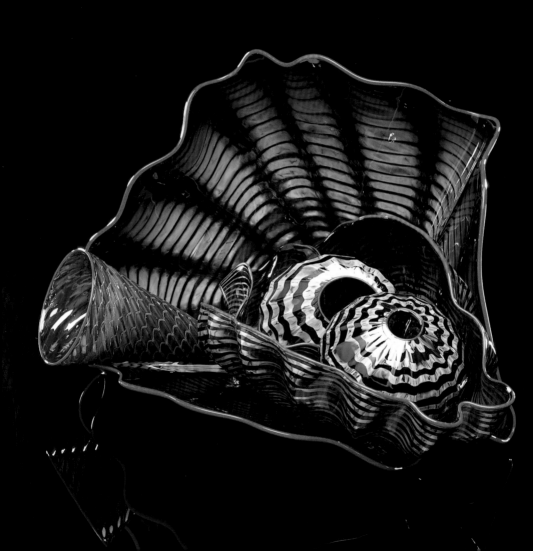

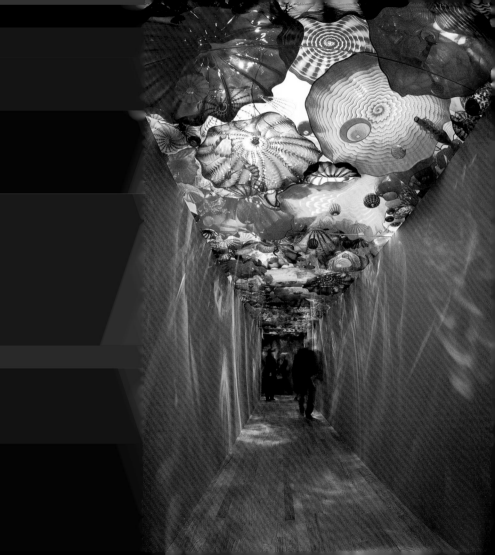

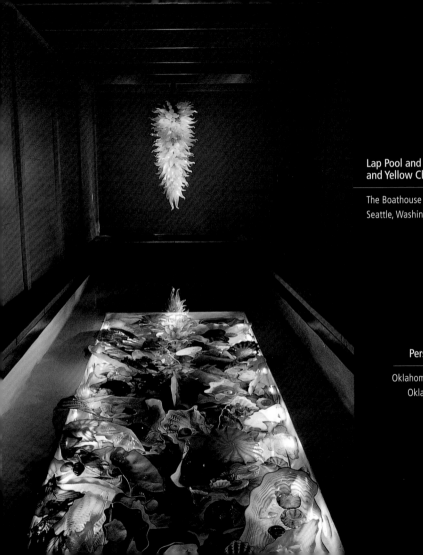

**Lap Pool and May Green
and Yellow Chandelier**

The Boathouse
Seattle, Washington, 1994

Persian Ceiling (det.

Oklahoma City Museum of
Oklahoma City, Oklaho
2002, 40

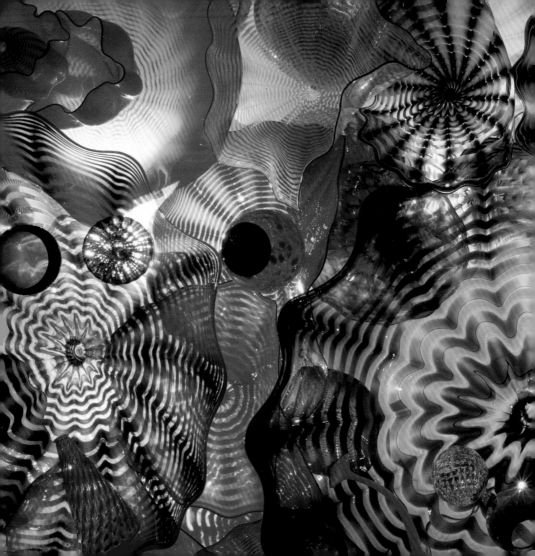

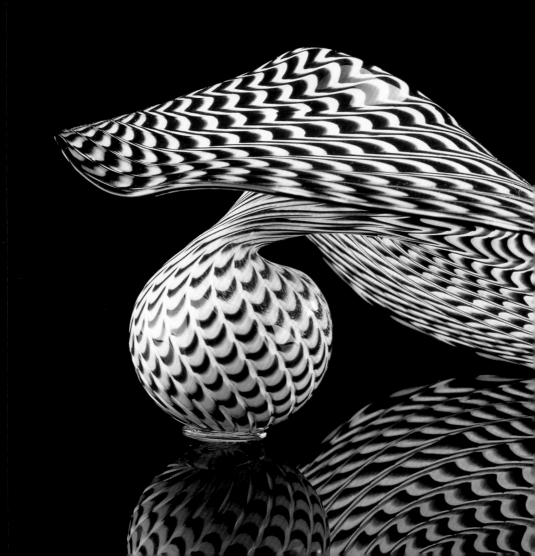

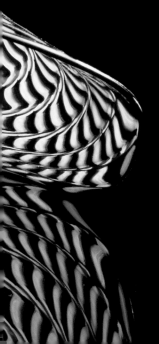

White and Oxblood Persian

1987, 5 x 10 x 8"

CHRONOLOGY

1941	Born September 20 in Tacoma, Washington, to George Chihuly and Viola Magnuson Chihuly.
1957	Older brother and only sibling, George, is killed in a Naval Air Force training accident in Pensacola, Florida.
1958	His father suffers a fatal heart attack at age 51. His mother goes to work to support Dale and herself.
1959	Graduates from high school in Tacoma. Enrolls in the College of Puget Sound (now the University of Puget Sound) in his hometown. Transfers to the University of Washington in Seattle to study interior design and architecture.
1961	Joins Delta Kappa Epsilon fraternity and becomes rush chairman. Learns to melt and fuse glass.
1962	Disillusioned with his studies, he leaves school and travels to Florence to study art. Discouraged by not being able to speak Italian, he leaves and travels to the Middle East.
1963	Works on a kibbutz in the Negev Desert. Returns to the University of Washington in the College of Arts and Sciences and studies under Hope Foote and Warren Hill. In a weaving class with Doris Brockway, he incorporates glass shards into woven tapestries.
1964	Returns to Europe, visits Leningrad, and makes the first of many trips to Ireland.
1965	Receives B.A. in Interior Design from the University of Washington. Experimenting on his own in his basement studio, Chihuly blows his first glass bubble by melting stained glass and using a metal pipe.

1966	Works as a commercial fisherman in Alaska to earn money for graduate school. Enters the University of Wisconsin at Madison, where he studies glassblowing under Harvey Littleton.
1967	Receives M.S. in Sculpture from the University of Wisconsin. Enrolls at the Rhode Island School of Design (RISD) in Providence, where he begins his exploration of environmental works using neon, argon, and blown glass. Awarded a Louis Comfort Tiffany Foundation Grant for work in glass. Italo Scanga, then on the faculty at Pennsylvania State University's Art Department, lectures at RISD, and the two begin a lifelong friendship.
1968	Receives M.F.A. in Ceramics from RISD. Awarded a Fulbright Fellowship, which enables him to travel and work in Europe. Becomes the first American glassblower to work in the Venini factory on the island of Murano. Returns to the United States and spends four consecutive summers teaching at Haystack Mountain School of Crafts in Deer Isle, Maine.
1969	Travels again throughout Europe and meets glass masters Erwin Eisch in Germany and Jaroslava Brychtová and Stanislav Libenský in Czechoslovakia. Returning to the United States, Chihuly establishes the glass program at RISD, where he teaches for the next fifteen years.
1970	Meets James Carpenter, a student in the RISD Illustration Department, and they begin a four-year collaboration.
1971	On the site of a tree farm owned by Seattle art patrons Anne Gould Hauberg and John Hauberg, the Pilchuck Glass School

experiment is started. Chihuly's first environmental installation at Pilchuck is created that summer. He resumes teaching at RISD and creates *20,000 Pounds of Ice and Neon*, *Glass Forest #1*, and *Glass Forest #2* with James Carpenter, installations that prefigure later environmental works by Chihuly.

1972 Continues to collaborate with Carpenter on large-scale architectural projects. They create *Rondel Door* and *Cast Glass Door* at Pilchuck. Back in Providence, they create *Dry Ice, Bent Glass and Neon*, a conceptual breakthrough.

1974 Supported by a National Endowment for the Arts grant at Pilchuck, James Carpenter, a group of students, and he develop a technique for picking up glass thread drawings. In December at RISD, he completes his last collaborative project with Carpenter, *Corning Wall*.

1975 At RISD, begins series of *Navajo Blanket Cylinders*. Kate Elliott and, later, Flora C. Mace fabricate the complex thread drawings. He receives the first of two National Endowment for the Arts Individual Artist grants. Artist-in-residence with Seaver Leslie at Artpark, on the Niagara Gorge, in New York State. Begins *Irish Cylinders* and *Ulysses Cylinders* with Leslie and Mace.

1976 An automobile accident in England leaves him, after weeks in the hospital and 256 stitches in his face, without sight in his left eye and with permanent damage to his right ankle and foot. After recuperating he returns to Providence to serve as head of the Department of Sculpture and the Program in Glass at RISD.

Henry Geldzahler, curator of contemporary art at the Metropolitan Museum of Art in New York, acquires three *Navajo Blanket Cylinders* for the museum's collection. This is a turning point in Chihuly's career, and a friendship between artist and curator commences.

1977 Inspired by Northwest Coast Indian baskets he sees at the Washington State Historical Society in Tacoma, begins the *Basket* series at Pilchuck over the summer, with Benjamin Moore as his gaffer. Continues his bicoastal teaching assignments, dividing his time between Rhode Island and the Pacific Northwest.

1978 Meets William Morris, a student at Pilchuck Glass School, and the two begin a close, eight-year working relationship. A solo show curated by Michael W. Monroe at the Renwick Gallery, Smithsonian Institution, in Washington, D.C., is another career milestone.

1979 Dislocates his shoulder in a bodysurfing accident and relinquishes the gaffer position for good. William Morris becomes his chief gaffer for the next several years. Chihuly begins to make drawings as a way to communicate his designs.

1980 Resigns his teaching position at RISD. He returns there periodically during the 1980s as artist-in-residence. Begins *Seaform* series at Pilchuck in the summer and later, back in Providence, returns to architectural installations with the creation of windows for the Shaare Emeth Synagogue in St. Louis, Missouri.

1981 Begins *Macchia* series.

1982	First major catalog is published: *Chihuly Glass*, designed by RISD colleague and friend Malcolm Grear.
1983	Returns to the Pacific Northwest after sixteen years on the East Coast. Works at Pilchuck in the fall and winter, further developing the *Macchia* series with William Morris as chief gaffer.
1984	Begins work on the *Soft Cylinder* series, with Flora C. Mace and Joey Kirkpatrick executing the glass drawings.
1985	Begins working hot glass on a larger scale and creates several site-specific installations.
1986	Begins *Persian* series with Martin Blank as gaffer, assisted by Robbie Miller. With the opening of *Objets de Verre* at the Musée des Arts Décoratifs, Palais du Louvre, in Paris, he becomes one of only four American artists to have had a one-person exhibition at the Louvre.
1987	Establishes his first hotshop in the Van de Kamp Building near Lake Union, Seattle. Begins association with artist Parks Anderson. Marries playwright Sylvia Peto.
1988	Inspired by a private collection of Italian Art Deco glass, Chihuly begins *Venetian* series. Working from Chihuly's drawings, Lino Tagliapietra serves as gaffer.
1989	With Italian glass masters Lino Tagliapietra, Pino Signoretto, and a team of glassblowers at Pilchuck Glass School, begins *Putti* series. Working with Tagliapietra, Chihuly creates *Ikebana* series, inspired by his travels to Japan and exposure to ikebana masters.

1990	Purchases the historic Pocock Building located on Lake Union, realizing his dream of being on the water in Seattle. Renovates the building and names it The Boathouse, for use as a studio, hotshop, and archives. Travels to Japan.
1991	Begins *Niijima Float* series with Richard Royal as gaffer, creating some of the largest pieces of glass ever blown by hand. Completes a number of architectural installations. He and Sylvia Peto divorce.
1992	Begins *Chandelier* series with a hanging sculpture at the Seattle Art Museum. Designs sets for Seattle Opera production of Debussy's *Pelléas et Mélisande*.
1993	Begins *Piccolo Venetian* series with Lino Tagliapietra. Creates *100,000 Pounds of Ice and Neon*, a temporary installation in the Tacoma Dome, Tacoma, Washington.
1994	Creates five installations for Tacoma's Union Station Federal Courthouse. Hilltop Artists in Residence, a glassblowing program for at-risk youths in Tacoma, Washington, is created by friend Kathy Kaperick. Within two years the program partners with Tacoma Public Schools, and Chihuly remains a strong role model and adviser.
1995	*Chihuly Over Venice* begins with a glassblowing session in Nuutajärvi, Finland, and a subsequent blow at the Waterford Crystal factory, Ireland.
1996	*Chihuly Over Venice* continues with a blow in Monterrey, Mexico, and culminates with the installation of fourteen

Chandeliers at various sites in Venice. Creates his first permanent outdoor installation, *Icicle Creek Chandelier*.

1997 Continues and expands series of experimental plastics he calls "Polyvitro." *Chihuly* is designed by Massimo Vignelli and copublished by Harry N. Abrams, Inc., New York, and Portland Press, Seattle. A permanent installation of Chihuly's work opens at the Hakone Glass Forest, Ukai Museum, in Hakone, Japan.

1998 Chihuly is invited to Sydney, Australia, with his team to participate in the Sydney Arts Festival. A son, Jackson Viola Chihuly, is born February 12 to Dale Chihuly and Leslie Jackson. Creates architectural installations for Benaroya Hall, Seattle; Bellagio, Las Vegas; and Atlantis, the Bahamas.

1999 Begins *Jerusalem Cylinder* series with gaffer James Mongrain in concert with Flora C. Mace and Joey Kirkpatrick. Mounts his most challenging exhibition: *Chihuly in the Light of Jerusalem 2000*, at the Tower of David Museum of the History of Jerusalem. Outside the museum he creates a sixty-foot wall from twenty-four massive blocks of ice shipped from Alaska.

2000 Creates *La Tour de Lumière* sculpture as part of the exhibition *Contemporary American Sculpture* in Monte Carlo. Marlborough gallery represents Chihuly. More than a million visitors enter the Tower of David Museum to see *Chihuly in the Light of Jerusalem 2000*, breaking the world attendance record for a temporary exhibition during 1999–2000.

2001 *Chihuly at the V&A* opens at the Victoria and Albert

Museum in London. Exhibits at Marlborough Gallery, New York and London. Groups a series of *Chandeliers* for the first time to create an installation for the Mayo Clinic in Rochester, Minnesota. Artist Italo Scanga dies, friend and mentor for over three decades. Presents his first major glasshouse exhibition, *Chihuly in the Park: A Garden of Glass*, at the Garfield Park Conservatory, Chicago.

2002 Creates installations for the Salt Lake 2002 Olympic Winter Games. The *Chihuly Bridge of Glass*, conceived by Chihuly and designed in collaboration with Arthur Andersson of Andersson· Wise Architects, is dedicated in Tacoma, Washington.

2003 Begins the *Fiori* series with gaffer Joey DeCamp for the opening exhibition at the Tacoma Art Museum's new building. TAM designs a permanent installation for its collection of his works. *Chihuly at the Conservatory* opens at the Franklin Park Conservatory, Columbus, Ohio.

2004 Creates new forms in his *Fiori* series for an exhibition at Marlborough Gallery, New York. The Orlando Museum of Art and the Museum of Fine Arts, St. Petersburg, Florida, become the first museums to collaborate and present simultaneous major exhibitions of his work. Presents a glasshouse exhibition at Atlanta Botanical Garden.

2005 Marries Leslie Jackson. Mounts a major garden exhibition at the Royal Botanic Gardens, Kew, outside London. Shows at Marlborough Monaco and Marlborough London. Exhibits at the Fairchild Tropical Botanic Garden, Coral Gables, Florida.

2006	Mother, Viola, dies at the age of ninety-eight in Tacoma, Washington. Begins *Black* series with a *Cylinder* blow. Presents glasshouse exhibitions at the Missouri Botanical Garden and the New York Botanical Garden. *Chihuly in Tacoma*—hotshop sessions at the Museum of Glass—reunites Chihuly and glassblowers from important periods in his artistic development. The film *Chihuly in the Hotshop* documents this event.
2007	Exhibits at the Phipps Conservatory and Botanical Gardens, Pittsburgh. Creates stage sets for the Seattle Symphony's production of Béla Bartók's opera *Bluebeard's Castle*.
2008	Presents his most ambitious exhibition to date at the de Young Museum, San Francisco. Returns to his alma mater with an exhibition at the RISD Museum of Art. Exhibits at the Desert Botanical Garden in Phoenix.
2009	Begins *Silvered* series. Mounts a garden exhibition at the Franklin Park Conservatory, Columbus, Ohio. Participates in the 53rd Venice Biennale with a *Mille Fiori* installation. Creates largest commission with multiple installations on the island resort of Sentosa, Singapore.

COLOPHON

This third printing of **CHIHULY PERSIANS** is limited to 3,500 casebound copies. © 2010 Chihuly Workshop, formerly Portland Press. All rights reserved. DVD is for private home viewing only.

Photography
Theresa Batty, Dick Busher, Shaun Chappell, Jack Crane, Claire Garoutte, Scott Hagar, Russell Johnson, Scott M. Leen, Teresa Nouri Rishel, Terry Rishel, Roger Schreiber, Chuck Taylor

Designer
Janná Giles

DVD Director
Peter West

Typeface
Frutiger

Printed and bound in China by Hing Yip Printing Co., Ltd.

CHIHULY™
WORKSHOP

Post Office Box 70856
Seattle, Washington 98127
800 574 7272
chihulyworkshop.com
ISBN: 978-1-57684-175-4

Front cover:
Oxblood Persian
with Black Lip Wrap
1987, 5 x 10 x 8"

Pages 18–19:
Persian Installation
Chancellor Park
San Diego, California
1988, 6 x 10½ x 6½'